Internati

HISTORY

From Ancient Roots

OF

to Modern Times

IRELAND

CILLIAN BYRNE

Disclaimer

The views and opinions expressed in this book are those of the author and do not necessarily reflect the official policy or position of any agency or organization. This book is for informational purposes only and while every attempt has been made to ensure that the information provided in this book is accurate and up-to-date, the author cannot guarantee that it is free from errors or inaccuracies.

978-1-4467-9732-7
Imprint: Lulu.com

To the people of Ireland, whose resilient spirit and rich history have inspired this journey.

FOREWORD

As I embark on the journey of reading 'The History of Ireland: From Ancient Roots to Modern Times,' the intricate lines of W.B Yeats' poem 'The Song of Wandering Aengus'

flood my mind - a masterful blend of Ireland's mythology, natural beauty, and passion that has become a symbolic representation of our Irish identity. I ponder the richness of our history, culture, and tradition that have allowed for such deep-rooted narratives.

Cillian Byrne, the author, is a historian who has lovingly dedicated years to examining the complex and vibrant story of our beloved Emerald Isle. It is with immense pleasure that I write the foreword to this work, a testament to the layers and paradoxes of our past, present, and future.

In his book, Byrne gracefully untangles the complex threads of our history, casting a keen and unbiased eye over the centuries. The ancient Celtic tribes, the

imprint of Christianity, the struggle for independence, the socio-economic transformations, the trials of the Troubles, and the contemporary strides towards a new Ireland - each chapter in this book opens a new doorway into the maze of our heritage.

What is most compelling about this book is that it is not merely a record of dates and events; it is a mirror reflecting the spirit of the Irish people. Byrne captures the resilience and determination that have enabled this small nation to withstand invasions, famines, civil war, and economic crises. He articulates the deep yearning for freedom and justice that has driven movements for independence and civil rights. And he encapsulates the unique Irish blend of wisdom and whimsy that

has produced world-renowned literature, music, and folklore.

While there are many books on Irish history, Byrne's approach is refreshing. He encourages us not only to look back and understand our history but also to engage with the present and anticipate the future. The closing chapters of the book invite us to explore the challenges and opportunities that lie ahead, providing food for thought for anyone interested in Ireland's place in the evolving global landscape.

Whether you are Irish by birth, by heritage, or by affinity, 'The History of Ireland: From Ancient Roots to Modern Times' is a journey worth undertaking. As Yeats said, "I have spread my dreams under your feet; tread

softly because you tread on my dreams." This book is an invitation to tread softly through the dreams, struggles, and victories of Ireland's past and to envision the dreams of its future. I hope you accept it with an open mind and a curious heart.

Patrick Duff

THE HISTORY OF IRELAND

reland, this verdant isle nestled in the Atlantic Ocean, offers an inviting landscape of rolling hills and craggy cliffs, carpeted in forty shades of green. Under the ever-changing skies, the land stretches

out in vibrant fields of emerald, making it instantly clear why it's earned the poetic epithet "The Emerald Isle." An island defined by its weather as much as its landscape, Ireland's climate blends the raw power of the Atlantic with the gentler touches of gulf-stream warmth, nurturing a fertile and lush environment.

Beyond its stunning vistas, Ireland is etched with ancient echoes, the silent stories of those who first set foot upon this land. The earliest human footsteps rustled in the grass around 10,000 BC, shortly after the last Ice Age, when small bands of hunter-gatherers arrived, following the retreat of the glacial ice. They found a land of bounty, of fish-filled rivers and game-rich forests, a perfect canvas on which

to etch the beginnings of Ireland's human story.

In these initial chapters of history, communities of Mesolithic or Middle Stone Age people settled, leaving traces of their existence in the form of primitive tools and bones. Their footprints were light upon the landscape, their mark seen only in these scant echoes, but they were the precursors of a rich tapestry of human life that would unfurl across the millennia.

As the centuries rolled on, the Bronze Age dawned around 2000 BC, witnessing a surge in population and advancements in farming techniques, metalworking, and the erection of megalithic monuments. Ireland's landscape became etched with the indelible marks of human

civilization, marks that echo into our present day. The mysterious spirals and symbols carved into the rocks of sites like Newgrange whisper of a culture whose depths we are only beginning to fathom.

New people came to this island during the Iron Age, which started around 500 BC. They spoke a different tongue, a language now known as Old Irish, a precursor to the Gaelic languages spoken today. These people were Celts, migrating from central Europe, bringing with them their distinct culture, art, and a complex societal structure.

The Celts did not write their history, but they sang it, they spoke it, and they lived it. They passed their stories from one generation to the next, their lore

taking root in the very soil of Ireland. These stories, their mythology and their wisdom, would shape the land's identity, infusing it with a spirit as distinctive and enduring as the Celtic knotwork that graces their ancient artifacts.

Ireland, as we understand it today, was not born overnight. This emerald jewel was slowly shaped, sculpted by the hands of time, climate, and the numerous people who dared to make it their home. From the first brave souls who ventured here after the ice receded, through the enigmatic builders of megalithic tombs, to the vibrant and influential Celts, each chapter of this history contributes to the complex, compelling narrative of this island nation. To truly know Ireland, one

must understand this rich and varied past, for it is the seed from which the complex tapestry of modern Irish society has blossomed.

Celts, bearers of a language and culture birthed in the heart of Europe, began to ripple outwards in waves of migration, reaching the verdant shores of Ireland around 500 BC.

Unlike the quiet whispers of the past, the arrival of these peoples reverberated through the centuries, leaving a resonating impact that's palpable even today.

Sailing the rough seas in hide-covered boats, these intrepid travelers were drawn to Ireland's lush landscape, settling throughout the island's diverse regions. Their society was tribal, decentralised, and egalitarian, led by chieftains and distinguished warriors, the best among equals, their stature earned through bravery, wisdom, and skill.

Celtic society was one of complexity and nuance, characterized by the fluidity of social roles. Warriors, as esteemed as they were, didn't hold absolute power. The druids, custodians of

knowledge and spirituality, maintained an equally pivotal role. They were the intermediaries between the Celts and their pantheon of gods, interpreters of the natural world, and guardians of the tribe's lore and law.

The language of these newcomers, an early form of Gaelic, was both melodious and expressive. It began to seep into the essence of the land, permeating every crag, every hill, every rippling brook. It was a language of poets and storytellers, an oral tradition that celebrated heroism, love, and the ever-changing natural world. The narrative tapestry woven from these ancient tales is an invaluable artifact, an intimate glimpse into the soul of Celtic Ireland.

Their artistic sensibilities were equally expressive. From the delicate traceries on ornate jewelry to the vibrant symbols adorning weaponry and ceremonial objects, Celtic art was not merely decorative but symbolic. It was an intricate language of swirling forms and twisting knots, embodying their complex cosmology and unending cycle of life.

For the Celts, the natural world wasn't just a resource to be exploited; it was a realm alive with divinity, every rock, river, and tree imbued with spirit. Their gods mirrored this understanding, each associated with a particular facet of the natural world. Lugh, the god of all skills, Brigid, the goddess of hearth and home, and Morrigan, the goddess of war and fate, were

all venerated and called upon in times of need.

Feasts and festivals marked the wheel of the year, aligning the tribal community with the rhythm of nature. Among these, Samhain, Imbolc, Beltane, and Lughnasadh held prominent positions, each celebrating a different aspect of the agrarian cycle - from the harvest's bounty to the rebirth of spring.

The Celts also had a system of laws, the Brehon laws, that governed every aspect of their society. These were surprisingly progressive for their time, recognizing the rights of women and children and encouraging peaceful resolution of disputes.

As the centuries passed, the Celtic influence permeated every facet of Irish life. The echoes of their language, their lore, and their laws intertwined with the cultural DNA of Ireland, forever changing the course of its history. The richness of their mythology, the lyrical beauty of their language, the vibrancy of their art, and their profound connection with nature left a profound imprint on the Irish consciousness, indelibly defining the unique identity of this emerald island.

n the interwoven fabric of the Emerald Isle's history, no strand glows as vividly as the lore spun by the Celts. Born from the lips of ancient bards and nurtured in the hearts of the people, this lore grew

into a vibrant mythology filled with magical creatures, heroic deeds, and divine interventions. The tales told around hearth fires illuminated the Celtic worldview, a profound tapestry of beliefs that connected every aspect of existence.

Prominent within this sacred tapestry were the Druids, respected figures whose wisdom flowed from a deep connection with the spiritual world. Their realm was one of magic and mystery, where knowledge of the natural world fused with the metaphysical. In their whispered incantations, they harnessed the raw energy of the universe, interpreting omens, shaping destiny, and guiding the tribe's spiritual practices.

As the Celtic tribes coalesced into kingdoms, the institution of the High Kings emerged. These figures, such as Brian Boru or Cormac mac Airt, were seen not merely as rulers but as embodiments of the land itself. Their strength was the strength of the kingdom; their wisdom, the wisdom of their people. In the stories that endured, they were frequently cast into roles that tested their mettle, their wisdom, and their ability to protect and serve the land they ruled.

Yet, the heart of Celtic mythology beats strongest in the tales of its heroes, those exceptional beings who straddled the boundary between mortal and divine. One such hero was Cú Chulainn, the Hound of Ulster. His exploits, from single-handedly defending Ulster

in the epic Táin Bó Cúailnge to his tragic early death, remain deeply woven into the fabric of Irish cultural memory. His strength, courage, and tragic destiny are a testament to the Celtic fascination with heroism and the fleeting nature of life.

Fionn mac Cumhaill, another legendary hero, was the leader of the Fianna, a band of noble warriors. His wisdom, acquired by accidentally tasting the Salmon of Knowledge, and his adventures with his comrades are the subject of many tales. Fionn's stories often conveyed moral lessons, emphasizing the virtues of courage, wisdom, and fairness.

Equally captivating are the mythological tales concerning the Tuatha Dé Danann, a divine race

said to have once ruled Ireland. After being driven underground by the invading Celts, they became the "Aos Sí" or "the People of the Mound," supernatural beings who lived in a parallel realm. They continued to interact with the human world, providing assistance, creating mischief, or teaching lessons, depending on the tale.

These characters and tales from Celtic mythology are more than mere stories; they are a reflection of the Celtic spirit, filled with bravery, wisdom, humor, and respect for the natural world. Like the intricate knotwork that embellishes Celtic art, the threads of these legends are entwined with the cultural identity of Ireland. Through countless generations, they have endured, providing a

rich source of inspiration, moral guidance, and a sense of continuity with the past. In the landscape, the language, and the collective memory of Ireland, the echoes of these ancient tales continue to resonate, carrying the spirit of the Celts into the modern era.

An unseen current was stirring in the east, a tide that would wash upon Ireland's shores and forever change its spiritual landscape. It came with the arrival of

Christianity in the 5th century, a transformative wave that forever altered the island's cultural and religious trajectory.

Central to this transition is a figure who has since become synonymous with Ireland - Saint Patrick. The boy who was captured by Irish pirates, endured six years of slavery, escaped, and then chose to return as a missionary, was the harbinger of this monumental shift. While his historical existence is not without contention, the influence attributed to him is undeniable.

Patrick arrived bearing a message of a single God, a concept seemingly at odds with the multitude of deities in Celtic polytheism. Yet, he was not a man to vanquish the old ways with a

sword, but rather to weave the new thread of Christianity into the existing cultural tapestry. Through his approach, the pantheon of Celtic gods gradually began to recede into the realm of folklore and legend, making way for the Cross.

The tale of Patrick using the three-leaved shamrock to explain the concept of the Holy Trinity encapsulates this subtle blending of belief systems. This simple plant, already imbued with meaning in the Celtic tradition, became a symbol of the Christian God's triune nature. Through such bridges of understanding, the new faith found its footing in the fertile ground of Ireland's spiritual landscape.

Christianity's spread was not solely the work of Patrick, though his efforts undeniably sowed the seeds. Other missionaries, like Saint Brigid and Saint Columba, nurtured these sprouts of faith, spreading their branches to the island's furthest corners. With their tireless dedication, monastic communities began to dot the landscape, becoming centers of learning, art, and spiritual development.

The illuminated manuscripts produced within the walls of these monasteries were a testament to the island's burgeoning Christian faith and its thriving culture. Among these, the Book of Kells, with its intricate designs and vibrant illuminations, stands as a beautiful convergence of Celtic artistic tradition and Christian

symbolism. Created in the 9th century, it remains one of the most exquisite artifacts of the early Christian era.

The wave of Christianity that swept over Ireland in these centuries was not a destructive force, but rather a transformative one. It respected and adapted to the undercurrents of Celtic spirituality, molding them into a new form. As the echoes of Druidic chants gradually faded, the tolling bells of Christian monasteries began to mark the rhythm of Irish life. The Emerald Isle, once the realm of the Celts and their pantheon of gods, was becoming a beacon of Christianity, shining brightly on the edge of the known world. Its journey was just beginning.

As Christianity took root in the fertile soil of Ireland, the Emerald Isle began a remarkable metamorphosis. The 6th to the 9th centuries marked a flourishing period in Irish history

known as the Golden Age, an era when saints and scholars lit a beacon of learning, art, and spirituality that shone across the European continent.

Ireland's numerous monastic communities were the heart of this intellectual and spiritual renaissance. Monasteries like Clonmacnoise, Glendalough, and Kells were not just spiritual sanctuaries but bustling centers of education, transcribing and preserving texts from Classical antiquity and creating beautiful religious manuscripts.

The artistic creativity of this period was extraordinary. Irish scribes produced stunning works of illuminated art, their pages resplendent with intricate Celtic designs and Christian

iconography. The Book of Kells, with its intricate knotwork, vivid colors, and elaborate depictions of the Gospels, is an emblem of this breathtaking confluence of faith and artistry.

However, the intellectual pursuit was not confined to religious matters alone. Irish scholars engaged in a broad spectrum of studies, encompassing philosophy, history, law, and linguistics. This scholarship, preserved and fostered within the seclusion of the monasteries, became a beacon of knowledge during a time when much of Europe was overshadowed by the Dark Ages.

One of the shining lights of this era was Columba, or Colum Cille, a prince-turned-monk. A scholar, scribe, and founder of

monasteries, he left an indelible imprint on Ireland before sailing across the sea to the island of Iona, where he established a renowned monastery. From this remote location, Columba played a pivotal role in spreading Christianity and Irish scholarship throughout Scotland.

Another renowned figure was Brigid of Kildare, one of Ireland's patron saints. Her life, imbued with the Christian virtues of charity and compassion, became the model for Irish sanctity. The monastery she founded in Kildare became a significant center of spirituality, learning, and craftwork, leaving a lasting legacy in the annals of Irish Christianity.

Even amidst the reverent silence of the scriptoriums and the solemn

chants in stone chapels, the cultural heart of Ireland continued to beat to the rhythm of its Celtic past. The ancient myths and sagas of heroes were still recited, now written down in manuscripts like the Book of the Dun Cow and the Book of Leinster, preserving the legacy of Ireland's rich oral tradition.

During these golden centuries, the island on the edge of the known world became a sanctuary of knowledge and faith. Irish missionaries, carrying their books and their fervor, ventured across Europe, establishing monasteries, teaching, and spreading the Gospel. The Emerald Isle's influence extended far beyond its windswept shores, casting its light into the future, forging an

indelible chapter in the annals of Irish history.

It was from the cold northern seas that a new force came upon Ireland in the 8th century. War cries echoed over the waves, heralding the arrival of the Vikings, seafaring warriors from

the lands we now know as Norway, Denmark, and Sweden. Their longships, swift and sleek, were an ominous sight as they breached Ireland's tranquil coastline.

First arriving as raiders, the Vikings targeted monastic communities like Iona, Lindisfarne, and Clonmacnoise, drawn by their relative wealth and lack of defenses. The monasteries, with their ornate relics and accumulations of offerings, presented a tantalizing wealth to these seafarers. The peaceful rhythm of monastic life was shattered by the Vikings' attacks, the sacred tranquillity replaced by the clang of battle and the cries of the besieged.

Yet the Vikings were not merely destroyers; they were also traders,

explorers, and settlers. They established permanent settlements along the Irish coast, including what would eventually become Dublin, Cork, Limerick, and Waterford. These settlements grew into bustling ports, their wharfs laden with goods from far-off lands, and became thriving centers of commerce and craftsmanship.

This dual nature of the Vikings, both as ruthless raiders and industrious settlers, played a significant role in shaping Ireland's development. Their presence spurred political changes, accelerating the shift from small kingdoms to larger territorial units capable of mustering defenses. They influenced Ireland's urban growth, with their fortified settlements evolving into some of Ireland's first true towns.

The interactions between the native Irish and the Viking settlers also led to significant cultural exchanges. The Norse brought with them new methods of craftwork, shipbuilding, and trade. Irish art and jewelry began to incorporate Norse elements, and Irish society absorbed new words from the Norse language.

The Vikings also played a role in expanding Ireland's overseas connections. Irish missionaries and scholars, often referred to as the 'island hoppers', travelled the known world, even reaching the court of Charlemagne. These connections fostered the flow of ideas and trade, with Ireland's influence reaching beyond its geographical boundaries.

Despite the initial brutality of their arrival, the Vikings eventually became part of the Irish societal fabric, intermarrying with the local population and adopting Christianity. Their presence, once a threat, ultimately became a catalyst for political, economic, and cultural evolution.

The Viking era, spanning from their first raids in 795 to the Battle of Clontarf in 1014, was a tumultuous chapter in Irish history. Yet amidst the clashes and the chaos, a dynamic exchange of cultures and ideas unfolded. The Irish landscape, the nascent towns, the artistic expressions, and the very bloodline of the Irish people were all subtly but indelibly marked by the passage of the dragon-prowed ships and their intrepid crews.

W hen the sails of Norman ships broke the horizon in 1169, they bore the heralds of another dramatic shift in Ireland's history. The Normans, originally Vikings who had settled

and become culturally assimilated in Northern France, had established themselves as potent rulers, boasting control over regions as diverse as England, Sicily, and parts of the Levant.

Their expedition to Ireland had its roots in dynastic disputes within the island, a call for assistance from the deposed King of Leinster, Diarmait Mac Murchada, spiralling into a significant overseas adventure for the Norman knights. Among them was Richard de Clare, better known as Strongbow, whose pivotal role in the invasion earned him significant land holdings and the hand of Mac Murchada's daughter, Aoife.

In a twist of fate, their arrival coincided with the ambitions of Henry II of England, who, under

the auspices of the papal bull Laudabiliter, sought to extend his overlordship over the island and curtail the growing power of his vassals, like Strongbow. By 1171, Henry had set foot on Irish soil, the first English monarch to do so, marking the beginning of centuries of English involvement in Ireland.

The Norman impact on Ireland was multifaceted. On a political level, they introduced a degree of feudal organization, though this never fully replaced the existing Gaelic structures. Their fortified settlements, typified by castles and walled towns, altered the physical landscape, transforming small settlements into bustling urban centers. They also brought new legal, economic, and social structures that would become

woven into the Irish societal fabric.

Moreover, they significantly influenced Ireland's agricultural practices, introducing new techniques and changing land ownership models. The open-field system of farming was a notable Norman contribution, as were the concepts of serfdom and manorialism, all of which reshaped the rural landscape of Ireland.

But the Norman legacy in Ireland was not simply one of domination. Over time, the boundaries between the Normans and the native Irish blurred. A process of cultural and intermarital blending occurred, described by the phrase 'Hiberniores Hibernis ipsis,' meaning 'more Irish than the Irish

themselves.' The Normans adopted the Irish language, customs, laws, and even dress, much to the chagrin of successive English monarchs who attempted to halt this cultural assimilation through statutes like the ones issued at Kilkenny in 1366.

In the rich tapestry of Irish history, the Norman threads added complex patterns. They were invaders, settlers, and innovators who, despite their initial foreignness, became an integral part of the Irish story. Their legacy, marked in stone castles, fertile farmlands, and vibrant towns, is a testament to the dynamic and continually evolving saga of the Emerald Isle.

By the late 13th century, the Norman hold on Ireland was waning. Their influence, once so prominent, was retreating to a few fortified areas known as the Pale. Outside these regions,

Gaelic culture and political structures began to resurge. Irish chieftains reclaimed lost territories, and the Brehon Laws, Ireland's native legal system, regained prominence over Norman feudal law.

However, the face of Ireland had been irrevocably changed. The towns, castles, agricultural practices, and elements of feudalism the Normans had introduced remained, merged with the Gaelic culture and society to form a distinct Irish identity. It was an amalgamation of traditions and influences, a testament to the island's multifaceted history.

Meanwhile, England's attention, often diverted by domestic issues and continental wars, was never fully turned toward its western

neighbour. When it did, it sought to curb the 'Gaelicisation' of the Norman-Irish through regulations like the Statutes of Kilkenny, laws intended to reinforce English customs and laws within the Lordship. However, these proved largely ineffective in reversing the cultural amalgamation.

The political landscape also shifted during this time. The original Norman Lordship of Ireland, recognised by the Papal Bull Laudabiliter, was replaced by the Kingdom of Ireland in 1542 under the English Crown. This change was part of a broader process of consolidation of power by the Tudor monarchy, seeking a stronger direct rule over Ireland.

Religious reforms were underway too, as the winds of the Protestant

Reformation swept over Europe. Henry VIII's break with Rome in the 1530s marked the beginning of a tumultuous period for Ireland, where the majority of the population remained firmly Catholic. The imposition of the Anglican faith met with significant resistance, setting the stage for centuries of religious tension.

While Ireland wrestled with these internal dynamics, it remained connected to the wider world. Irish soldiers, known as Gallowglasses, served as mercenaries in the Scottish wars. Irish monasteries and scholars maintained contacts with their European counterparts, and trade with Europe, especially in the booming wool industry, continued to link Ireland with the continent.

This period, a patchwork of consolidation, resistance, and change, was a crucial stage in Ireland's journey. The Middle Ages, with their ebb and flow of influences, had shaped a unique society where Norman castles stood alongside Gaelic round towers, where English common law mingled with Brehon law, and where an Irish identity, as diverse as the island's verdant landscape, continued to evolve.

T he 16th and 17th centuries marked a period of intensified English control over Ireland, culminating in a series of large-scale settlements known as the Plantations. These

deliberate colonisations were not only a means to quell the Gaelic Irish and Anglo-Norman population but also an attempt to 'civilise' Ireland by introducing Protestant English and Scottish settlers.

The plantations began in Laois and Offaly in the mid-16th century but expanded significantly under the reign of James I. Ulster, the northernmost province of Ireland and a stronghold of Gaelic resistance, was the focus of the largest and most systematic plantation. Thousands of English and Scottish settlers were given land confiscated from the native Irish, dramatically altering the demographic and cultural landscape of the region.

This period also saw the culmination of the Tudor conquest of Ireland. Despite the Gaelic Irish and Anglo-Norman lords' resistance, the English Crown, now under the rule of Elizabeth I, succeeded in extending its control over the whole island by the early 17th century. The defeat of Irish and Spanish forces at the Battle of Kinsale in 1601 and the subsequent Flight of the Earls in 1607 signaled the end of Gaelic Ireland's political power.

With their dominion over Ireland secure, the English Crown sought to consolidate its rule and anglicise the population. English became the enforced language of legal, political, and educational institutions, leading to a gradual decline in the use of the Irish language. The native Gaelic

culture, laws, and customs faced suppression, replaced by English law and social practices.

Simultaneously, religious tension escalated. The Protestant Reformation had established a state church independent of Rome in England, but Ireland remained predominantly Catholic. The English authorities sought to establish the Church of Ireland and suppress Catholicism, leading to increased friction and religious persecution.

The cultural and religious suppression, combined with the dispossession of land during the Plantations, led to deep-seated resentment and tension. Resistance, rebellion, and conflict marred the period, creating deep divides that would cast long

shadows over the centuries to come. From the echoes of battle cries to the silent protest of maintaining Gaelic traditions, the Irish people navigated a path of resistance and resilience during these challenging times. This era, one of subjugation and struggle, would leave indelible marks on the Irish consciousness, shaping the discourse of identity, faith, and belonging in Ireland.

From the mid-17th century to the close of the 18th, Ireland was a theatre of violent contestations. The internal strife of this period, punctuated by external conflicts, transformed

Ireland politically, religiously, and socially. It was a time when Ireland's fate hung in the balance, shaped by events that would leave lasting imprints on its national narrative.

The period began with the bloody conflicts of the Wars of the Three Kingdoms, involving England, Scotland, and Ireland. Rooted in political, religious, and constitutional issues, these wars were a vortex of shifting alliances and visceral battles. The Irish Confederate Wars, a segment of these larger conflicts, saw the establishment of the Catholic Confederation at Kilkenny, attempting to self-govern and secure religious freedom for Catholics in Ireland.

However, the end of these wars with the Cromwellian conquest saw a brutal period for Ireland. Oliver Cromwell's campaign was marked by intense violence, and his policy of land confiscation further escalated the dispossession begun with the Plantations. The social and political fabric of Ireland was further torn asunder with the exiling of Catholic landowners to the less fertile lands of Connaught in the west.

The remainder of the 17th century saw the religious and political tension escalate into the Williamite War. The conflict between the Protestant William of Orange and the Catholic King James II extended into Ireland, which remained a stronghold of Jacobite support. The war concluded with the Protestant victory at the Battle

of the Boyne, a landmark event now deeply embedded in Ireland's collective memory.

The 18th century brought relative peace but was not devoid of turbulence. The Penal Laws enacted in this era further reduced the rights of Catholics and other dissenters, embedding religious discrimination in the fabric of the Irish constitution. Discontentment simmered, leading to a surge in secret societies and localised rebellions.

The influence of the American Revolution and the French Revolution was keenly felt in Ireland. These global events, bearing ideas of republicanism and equality, inspired the formation of the Society of United Irishmen. Led by figures like

Theobald Wolfe Tone, the society sought to reform the Irish Parliament and, later, aimed for an independent Irish Republic. Their aspiration culminated in the failed rebellion of 1798, a bloody conflict that brought temporary martial law upon Ireland.

This chapter of Ireland's history, fraught with wars and rebellions, was instrumental in shaping its future. The political consciousness of Ireland had awakened, heralding a new era where demands for equality, self-governance, and independence would become increasingly pronounced. Ireland's landscape bore the scars of battle, its demography had been altered, and a religious divide had been deepened. Yet, within these tumultuous times, the resilience

and aspirations of the Irish people shone as brightly as the guiding northern star, navigating the island nation towards a future of their envisioning.

The 18th century in Ireland was a time of contrasts, where the seeds of discontent sown by the wars and plantations of the previous century began to sprout in the

form of social and political awakenings, even as the era was marked by the dominance of the Anglo-Irish Ascendancy.

This class, consisting mainly of Protestant landowners, held a position of wealth and influence in society, owning large estates and wielding political power. They were the members of the Irish House of Lords, and they dominated the House of Commons despite the Catholic majority of the population. The Ascendancy was epitomized by the Georgian squares and grand country houses, such as the Powerscourt House in Wicklow and Castletown House in Kildare, which became the centers of their cultural and social lives.

Yet, beneath the sheen of the Ascendancy, Ireland was stirring. The Penal Laws had left the majority Catholic population economically disadvantaged and politically marginalised, and dissent was brewing. This century saw the rise of secret agrarian societies, like the Whiteboys and Ribbonmen, who carried out nocturnal protests against exploitative landlords, tithes, and other forms of social injustice.

In the north, the seeds of industrialisation began to sprout in linen, shipbuilding, and engineering, especially in the burgeoning city of Belfast. The Presbyterian Scots-Irish there, though Protestants, also faced discrimination due to their faith and began to voice demands for greater rights and recognition. It

was amongst these dissenting voices that movements for political reform found fertile ground.

The influence of Enlightenment ideas from Europe and revolutionary sentiments from America and France also seeped into Irish society. Pamphlets, poetry, and ballads became vehicles for political expression, igniting imaginations with thoughts of republicanism, rights, and reforms. Inspired by these ideas, the Society of United Irishmen was founded, advocating for a non-sectarian, independent Irish republic.

This period also witnessed the emergence of a distinctive Irish voice in literature, with writers like Jonathan Swift and Oliver Goldsmith penning works that

critiqued the social conditions and championed Irish identity. Meanwhile, traditional Irish music and Gaelic culture, though under pressure, survived and evolved, often becoming symbols of resistance against Anglicisation.

Thus, the 18th century was a crucible in which the identity of modern Ireland was forged. Amidst the grandeur of the Ascendancy and the simmering discontent of the disadvantaged, the ideas of political rights, religious equality, and national identity were taking shape, setting the stage for the profound transformations of the centuries to come.

As the 19th century dawned, Ireland was on the precipice of a significant transformation. The echoes of the failed 1798 rebellion were still ringing when the Act of Union of

1800 was passed, binding Ireland closer to Britain than ever before. The Irish Parliament was abolished, and Ireland was represented in the Westminster Parliament in London. The promises of Catholic emancipation, a vital sweetener to make the Union palatable to some, were initially reneged on, creating a sense of betrayal and disillusionment.

However, the Union was not accepted passively. The first half of the 19th century saw the rise of a powerful movement for Catholic emancipation, led by the charismatic Daniel O'Connell. Known as 'The Liberator,' O'Connell marshalled the power of public opinion through mass rallies, known as 'Monster Meetings,' demonstrating the

strength of demand for Catholic rights. His efforts were rewarded when the Catholic Emancipation Act was passed in 1829, allowing Catholics to sit in the Westminster Parliament.

O'Connell's next battle was for the repeal of the Act of Union and the restoration of an Irish Parliament. Although he failed to achieve this goal, his methods of peaceful mass mobilisation left an indelible mark on Irish political activism and were seen as a precursor to later nationalist movements.

While political developments were unfolding, Ireland was also experiencing a cultural awakening. There was a renewed interest in Ireland's Gaelic past, its language, and its cultural heritage. Figures like Thomas Davis and others

associated with the Young Ireland movement championed Irish culture and identity, providing the burgeoning political nationalism with a rich cultural backdrop.

Yet, this era was not just about political and cultural changes. Ireland's landscape was being transformed by the construction of canals and then railways, linking towns, improving communication, and providing a stimulus for trade. The first half of the 19th century also saw a substantial increase in population, with numbers reaching around 8 million on the eve of the Great Famine.

The Act of Union and the birth of the emancipation and repeal movements, therefore, represented a pivotal period in Irish history. The struggle for

rights and recognition, the push against the Union, and the awakening of a distinctly Irish cultural consciousness were shaping a new national identity. The threads of defiance, resilience, and aspiration spun during this era would be woven into the tapestry of Ireland's forthcoming struggle for independence.

In the mid-19th century, Ireland was hit by a calamity that left deep scars on the nation's psyche: the Great Hunger, or An Gorta Mór, commonly known outside Ireland as the Irish Potato

Famine. A fungal disease, Phytophthora infestans, destroyed the potato crops, which constituted the primary food source for the majority of the population, particularly the rural poor. The famine years, between 1845 and 1852, were a period of intense suffering, marked by widespread starvation, disease, and death.

While the failure of the potato crop was a natural disaster, its devastating impact was exacerbated by political and economic factors. Ireland, under the Act of Union, was part of the United Kingdom, and the British government's response to the crisis has been the subject of much scrutiny and criticism. Free-market economic policies, inadequate relief measures, and

the continued export of food from Ireland even as people starved, are considered by many to have contributed to the scale of the tragedy.

The Great Hunger led to significant demographic changes. It is estimated that around one million people died, and another million emigrated, leading to a drastic population decline. Those who emigrated, primarily to the United States, Canada, and Australia, created a global Irish diaspora and marked the beginning of the 'age of mass migration.' The tales of these 'famine refugees' are an integral part of the Irish diaspora's collective memory.

The famine also had profound social, political, and cultural effects. It further polarized

relations between the Irish and the British, sowing the seeds of nationalist sentiment. The failures of the response to the famine led to increased calls for Irish self-governance and the end of the Union. The desperate conditions also prompted social changes, including land reform, as the shortcomings of the existing system were brutally exposed.

Culturally, the Great Hunger entered folk memory, kept alive through stories, songs, and later, in literature and art. Its memory became a potent symbol of suffering, injustice, and resilience that resonates in Irish identity even today.

In its wake, the famine left a transformed Ireland. An island of emigration rather than

immigration, with a declining population, and an increasing determination to achieve autonomy and justice. The tragedy of the Great Hunger was a catalyst for change, marking the end of one chapter of Irish history and the beginning of another.

Following the devastation of the Great Famine, the second half of the 19th century in Ireland was characterized by significant sociopolitical shifts, which propelled the island further

along the path of nationalism and cultural self-discovery. One of the major disputes of this period, with roots stretching back to the plantations of previous centuries, was over land.

Irish land had long been controlled by an Anglican Ascendancy who were often absentee landlords, with Catholic tenant farmers bearing the brunt of high rents and the threat of eviction. In response, a series of agrarian movements mobilized for land reform, advocating for the 'Three Fs': fair rent, fixity of tenure, and free sale. The Land League, with Charles Stewart Parnell as one of its figureheads, organized boycotts and protests against landlord injustices, marking what came to be known as the 'Land War.' The persistent

agitation led to a series of Land Acts that ultimately resulted in the transfer of ownership from landlords to tenants, a significant victory for the rural poor.

Simultaneously, the political arena was buzzing with the question of Home Rule, aiming to achieve self-governance for Ireland while maintaining its link with Britain. Parnell, the 'Uncrowned King of Ireland,' led the Irish Parliamentary Party in Westminster and skillfully negotiated for Irish interests. Though the Home Rule bills he championed were ultimately unsuccessful, they stirred a profound discourse on Irish nationhood that echoed in the decades that followed.

Parallel to these developments, the period also saw a flourishing Gaelic Revival. Efforts were made to restore the Irish language, which had been severely eroded due to famine and anglicization. The Gaelic Athletic Association was founded to promote indigenous Irish sports, and the Gaelic League aimed to revive the Irish language. These cultural institutions played an essential role in bolstering an Irish identity distinct from Britain, fueling the burgeoning nationalist spirit.

Thus, the latter half of the 19th century witnessed Ireland wrestling with major land reforms, asserting its political aspirations, and experiencing a cultural renaissance. The nation was gradually realigning itself, closing the gap between the Ireland of

yore and the Ireland it envisioned for the future. Every victory, setback, and experience of this period shaped the Ireland that stepped into the 20th century, ready to confront its destiny with renewed vigor.

As the 20th century dawned, the winds of change began to blow across Ireland with increasing intensity. A new generation was rising, dissatisfied with the slow

progress of constitutional nationalism and inspired by the waves of revolutionary spirit sweeping across the globe. This generation was to steer Ireland into a tumultuous period of rebellion and warfare, fundamentally altering its trajectory.

The pivotal event that marked the beginning of this era was the Easter Rising of 1916. A small group of radicals, drawn from the Irish Republican Brotherhood, the Irish Volunteers, and the Irish Citizen Army, launched an insurrection in Dublin, aiming to end British rule and establish an independent Irish Republic. Although the rebellion was swiftly quashed, and its leaders executed, it lit the flame of a broader independence movement. The

handling of the Rising and its aftermath by the British authorities, particularly the widespread arrests and the execution of the leaders, shifted public sentiment significantly in favour of the rebels.

Following the Rising, the struggle for independence entered a more intense phase. The Sinn Féin party, under the leadership of Eamon de Valera, won a landslide victory in the 1918 general election and declared an Irish Republic, setting up a breakaway government, Dáil Éireann. The Irish Volunteers morphed into the Irish Republican Army, and the stage was set for a full-scale conflict, the Irish War of Independence.

From 1919 to 1921, the War of Independence raged, characterized by guerrilla warfare, political assassinations, and reprisals. Despite being outmanned and outgunned, the IRA, through a campaign of ambushes and raids, managed to make significant parts of the country ungovernable. Simultaneously, the Dáil worked to establish the structures of an independent state, creating a court system, a police force, and seeking international recognition for the Irish Republic.

The War of Independence was not just a military and political struggle; it was also a battle for hearts and minds. Both sides used propaganda to win public support, while atrocities and reprisals hardened attitudes. It was a time

of upheaval and transformation, a time when the future of Ireland was being forged in the fires of conflict, setting the stage for the dramatic events that were yet to unfold.

The year 1921 marked a turning point in the history of Ireland. The War of Independence culminated in a truce and negotiations between the British government and

representatives of the Irish Republic. The outcome was the Anglo-Irish Treaty, which offered Ireland a status of dominion within the British Empire, similar to Canada and Australia, and partitioned the island into Northern Ireland and the Irish Free State.

The Treaty was contentious. It provided for the partition of Ireland, with six northern counties remaining part of the United Kingdom. Additionally, members of the new Irish Free State's parliament would be required to swear an oath of allegiance to the British monarch. While some saw the Treaty as a stepping stone towards complete independence, others viewed it as a betrayal of the Irish Republic declared in 1916

and ratified by the popular mandate in 1918.

The Dáil Éireann split over the Treaty, with a slim majority voting in favour. Those opposed, including prominent figures such as Éamon de Valera and Cathal Brugha, walked out of the Dáil, refusing to accept the decision. The Irish population, too, was divided in its support, and the stage was set for a tragic fratricidal conflict: the Irish Civil War.

From 1922 to 1923, pro-Treaty forces, who formed the provisional government of the Irish Free State, and anti-Treaty forces, who were opposed to the compromises of the Treaty, battled in a war that was, in many ways, more bitter and personal than the War of Independence. The Civil

War included several atrocities, including the execution by the Free State of anti-Treaty prisoners. The conflict left deep scars, both physical and psychological, on the Irish landscape and psyche. Families, communities, and former comrades were torn apart, creating divisions that lingered for generations.

The Civil War finally ended in 1923 when the anti-Treaty forces laid down their arms, but not before it had marked a profound, often painful, transition from British rule to self-governance. Despite the turmoil, a new nation had emerged: the Irish Free State. A state not yet fully independent, divided and scarred by conflict, but one that held within itself the promise and challenge of forging a distinct path into the future.

In the aftermath of the Civil War, the Irish Free State faced the immense task of nation-building. In these early years, the leaders of the Free State, primarily drawn from the pro-Treaty side of the

Civil War, had to create a functioning state apparatus, restore law and order, and deal with a multitude of social, economic, and political issues.

The 1920s and 1930s were marked by efforts to consolidate the state and assert its independence. The constitution of the Free State was replaced in 1937 with a new constitution, Bunreacht na hÉireann, which further distanced Ireland from Britain, renaming the state as simply 'Ireland' or 'Éire.' The office of the British-appointed Governor-General was replaced with the role of a President, and the state continued to dismantle the remaining constitutional links with Britain.

Despite the political advances, the new state faced serious economic

challenges. The global economic depression in the 1930s hit Ireland hard, particularly its agricultural sector. Domestically, the government adopted protectionist policies to foster the growth of industry, which resulted in some degree of industrial development, albeit with a considerable economic cost.

Socially and culturally, the new state saw the entrenchment of conservative values. The Catholic Church had significant influence on society and the state, impacting education, health, and social policies. The Irish language, though not as widely spoken, was promoted as a core part of national identity, and efforts were made to foster a distinctly Irish culture.

Yet, Ireland in these years was also a place of deep divisions and challenges. The legacy of the Civil War still lingered, influencing politics and society. The partition of the island into North and South remained a contentious issue, contributing to tensions that occasionally erupted into violence.

The early years of the Free State, therefore, were a time of significant transition, of both successes and failures. Amidst all the struggles and challenges, the new state was gradually defining its identity and carving out its place in the world. The decades that followed would continue to see Ireland grapple with its past while striving to shape a better future.

The dark clouds of the Second World War that descended over Europe in the late 1930s brought a unique set of challenges and opportunities for Ireland. Under the leadership of

Taoiseach (Prime Minister) Éamon de Valera, who had long since reconciled with his erstwhile opponents from the Civil War, the Irish state proclaimed a stance of neutrality, or as it was termed domestically, "The Emergency."

Neutrality was a pragmatic choice, reflecting Ireland's desire to assert its independence from Britain and its reluctance to enter a war that had little to do with its national interests. At the same time, it was a precarious balancing act, given the geographical proximity and historical ties with Britain, and the existential threat posed by Nazi Germany.

During these war years, the Irish state faced various challenges, including the risk of invasion, shortages of essential supplies due

to the British naval blockade, and the impact on trade and economy. Despite these difficulties, the state managed to maintain its neutrality throughout the war, a stance that received popular support.

While officially neutral, Ireland's position was fraught with contradictions. On one hand, it provided some support to the Allies, such as sharing intelligence and returning downed Allied airmen. On the other hand, de Valera's controversial decision to offer condolences to Germany on the death of Hitler in 1945 highlighted the complexities of Irish neutrality.

The Second World War also had profound implications for the relationship between Ireland and Northern Ireland. The separate

paths taken by the two during the war underscored the partition, even as the shared challenges of the war period necessitated a certain level of cooperation.

In the grand scheme of Irish history, the era of "The Emergency" was a critical period that tested the young nation's resilience and diplomacy. It was a time that further asserted Ireland's independence on the international stage, setting the stage for the country's post-war evolution.

The years following the Second World War presented a mixed picture for Ireland. The country was left largely unscathed by the physical devastation of the war, but it faced

considerable economic and social challenges. For much of the 1950s, Ireland struggled with economic stagnation, unemployment, and a high rate of emigration.

The protectionist economic policies pursued since the foundation of the state had limited success in creating a sustainable industrial base. Agriculture, the backbone of the economy, was heavily dependent on the British market and vulnerable to price fluctuations. The lack of job opportunities led many young Irish men and women to emigrate, primarily to Britain and the United States, in search of better prospects.

However, the late 1950s and 1960s saw significant shifts in Ireland's economic policy and society. The

government, under the leadership of Taoiseach Seán Lemass, moved towards a more open and outward-looking economy. Policies to attract foreign investment, particularly from America, were initiated. Ireland applied for membership of the European Economic Community, marking a shift in its economic orientation away from Britain and towards Europe.

On the social front, the period was marked by gradual change. The influence of the Catholic Church on society remained strong, but there were signs of increasing secularisation. Television was introduced in the 1960s, bringing the wider world into Irish living rooms and exposing the society to global influences.

The question of Northern Ireland remained unresolved. The partition was a source of discontent, and the plight of the Catholic minority in the North was a cause of concern. This issue, which had been simmering in the background, was about to come to the forefront, ushering in a troubled and violent period known as "The Troubles."

Thus, the post-war decades were a time of significant economic, social, and political transformation for Ireland. It was a period that saw Ireland taking important steps towards modernisation, even as it grappled with enduring challenges from its past.

I n the late 1960s, the relative calm that had existed in Northern Ireland since its creation was shattered. Sparked by a civil rights movement against the discrimination faced by the

Catholic minority, Northern Ireland was plunged into a violent, three-decade-long conflict known as "The Troubles."

This period was marked by sectarian violence between the mainly Catholic nationalists, who sought a united Ireland, and the mainly Protestant unionists, who wished to remain part of the United Kingdom. Armed groups such as the Irish Republican Army (IRA) and the Ulster Volunteer Force (UVF) played key roles, with the conflict also involving the British army and the police.

The Troubles were a time of deep social and political division, characterised by bombings, shootings, and widespread civil unrest. Key events, such as Bloody Sunday in 1972, when British

soldiers shot 28 unarmed civilians during a protest march, and the hunger strikes of 1981, led by Bobby Sands and other prisoners demanding political status, had profound impacts on the course of the conflict and the consciousness of those involved.

Throughout this time, the Republic of Ireland was deeply affected by the events in the North. The government, while officially committed to peaceful reunification, grappled with the challenge of managing its relationship with Britain, addressing the grievances of the nationalist community in the North, and dealing with the violence spilling over its borders.

However, amid the violence, there were efforts to find a peaceful

solution. The Anglo-Irish Agreement of 1985, which gave the Irish government an advisory role in Northern Ireland's government while confirming that Northern Ireland would remain part of the United Kingdom until a majority of its citizens agreed to join the Republic, was one such attempt.

The Troubles were a complex and tragic chapter in Irish history. It was a time that tested the resolve and resilience of the Irish people, brought profound changes to Irish society and politics, and had lasting impacts on the relationship between Ireland, Northern Ireland, and Britain.

By the 1990s, after decades of conflict, there was a growing realisation that a military solution to the Troubles was unachievable. Both sides were weary from the violence, and

public sentiment was shifting towards a desire for peace. This change in attitude set the stage for a peace process that would result in the 1998 Good Friday Agreement.

Negotiated by the governments of the United Kingdom and Ireland and the political parties of Northern Ireland, the Agreement was a complex and finely balanced deal. It recognised Northern Ireland as part of the United Kingdom but allowed for a vote on Irish unity if it appeared likely that a majority in Northern Ireland would support it.

Moreover, the Agreement established a power-sharing assembly in Northern Ireland to ensure representation of both communities. It also created new

institutions to manage relations between Northern Ireland, the Republic of Ireland, and the United Kingdom, acknowledging the unique and interconnected relationships between these entities.

The path to the Good Friday Agreement was far from easy, marked by several setbacks and punctuated by acts of violence. Yet, the Agreement was endorsed in referenda by significant majorities in both parts of the island, illustrating a widespread desire for peace.

The Good Friday Agreement did not solve all the problems of Northern Ireland. There remained deep divisions within society, and the legacy of the conflict continued to impact the political

landscape. However, it did represent a significant milestone on the road to peace, marking the formal end of the Troubles and beginning a new chapter in the shared history of Ireland and Northern Ireland.

As Ireland entered the 21st century, it embarked on a new era defined by dramatic changes and fresh challenges. The island, still healing from the scars of the Troubles,

began to carve out a new identity on the global stage.

Economically, the Republic of Ireland experienced an unprecedented period of growth at the turn of the century. Dubbed the "Celtic Tiger", this boom was propelled by high-tech industries, foreign investment, and progressive economic policies. Cities like Dublin and Cork transformed into vibrant economic centres, and for the first time in its modern history, Ireland began to attract immigrants, reversing its long-standing trend of emigration.

However, this prosperity was not without its pitfalls. The global financial crisis of 2008 hit Ireland hard, leading to a severe economic recession. Banks collapsed,

unemployment soared, and the government was forced to implement harsh austerity measures. Yet, despite these hardships, the Irish economy showed resilience and began to recover towards the end of the decade.

Socially, Ireland underwent significant transformation. Traditional norms began to give way to more liberal values. The influence of the Catholic Church receded in the wake of various scandals and changing societal attitudes. Landmark referenda on marriage equality in 2015 and abortion rights in 2018 reflected the shift in public opinion and underscored the evolving Irish identity.

Politically, the peace process in Northern Ireland continued to face challenges, with occasional surges in sectarian tensions. Yet, the power-sharing institutions, albeit with periodic suspensions, largely held, and cross-community relations slowly improved. The question of Irish reunification gained renewed attention in the wake of the United Kingdom's decision to leave the European Union, adding a new dimension to Ireland's future.

Internationally, Ireland cemented its place in the European Union, navigating through crises and contributing to the bloc's evolution. At the same time, it maintained its distinct global identity, leveraging its diaspora, cultural influence, and diplomatic efforts.

In this unfolding narrative of the 21st century, the story of Ireland is one of resilience and transformation. It is a tale of a nation continuously shaped by its past, yet boldly embracing its future. It is a saga of an island small in size but large in spirit, navigating the complexities of its internal divisions and the wider world with determination and hope. This is the story of Ireland, an ancient land forever in the making.

Т he dawn of the third decade of the 21st century finds Ireland at an intriguing crossroads. The tumultuous echoes of the past have subsided into a relative murmur, while

ahead lie roads as yet untraveled, brimming with promise and complexities in equal measure.

One of the most compelling questions that looms over Ireland's future is the issue of reunification. The Good Friday Agreement, which has served as the bedrock of peace for over two decades, provides a mechanism for a vote on Irish unity if it appears likely that a majority would support such a move. The repercussions of the United Kingdom's decision to leave the European Union, coupled with demographic shifts and changing attitudes within Northern Ireland, have pushed the conversation on Irish unity into mainstream discourse.

However, the path to reunification, should it be pursued, is strewn

with challenges. While the desire for a united Ireland resonates deeply within the nationalist sentiment, the realities of merging two distinct economies, healthcare systems, legal jurisdictions, and educational systems, each with its own historical trajectory, are daunting. The complexities are not merely logistical; emotionally and culturally, the amalgamation would require careful handling to ensure that the unionist community, many of whom identify strongly with British identity, do not feel marginalized. It is a challenge that calls for careful diplomacy, open dialogue, and above all, a generosity of spirit on all sides.

In parallel with the internal debate on reunification, Ireland's future is also intrinsically linked with its

role in the European Union. Despite the trials of economic recessions and austerity measures, Ireland has consistently affirmed its commitment to the European project. As one of the Union's fastest-growing economies, it has evolved from a peripheral state to a confident participant in the EU's core.

The post-Brexit landscape presents both challenges and opportunities. Ireland is now the only English-speaking member in the Union, and this positions it uniquely as a bridge between the EU and the English-speaking world. Simultaneously, it needs to manage its complex relationship with the UK, a key trading partner, and its commitment to the EU's Single Market and Customs Union.

Environmental sustainability, digital innovation, and social equality are other areas where Ireland, like many other countries, will need to focus. Climate change and the transition to a green economy, harnessing the potential of digital technologies, and addressing socio-economic disparities will be key to ensuring a prosperous and inclusive future.

In all these, Ireland's greatest strength lies perhaps in its people. The Irish, known for their resilience, creativity, and global outlook, have continuously adapted to and shaped the course of their history. As they face the future, they carry with them the collective wisdom of their past and the hopeful promise of their potential. The future of Ireland is an unwritten chapter in the

continuing story of this remarkable island, waiting to be penned with the bold and careful strokes of its people.